100

T

GREAT
PASTEL
PAINTING

MIRANDA FELLOWS

CONSULTANT: BRIAN DUNCE

NORTH

A QUARTO BOOK

Copyright © 1994
Quarto Inc.

First published in the
U.S.A. by North Light
Books, an imprint of
F & W Publications,
Inc.
1507 Dana Avenue
Cincinnati, Ohio
45207

ISBN 0-89134-564-7

This book was
designed and
produced by
Quarto Inc.
The Old Brewery
6 Blundell Street
London N7 9BH

Manufactured by
Bright Arts (Singapore) Pte Ltd
Printed in Singapore by
Star Standard Industries Pte Ltd

Contents

INTRODUCTION
PAGE 6

MAKING A START
PAGE 8

1
A basic
palette
page 8

2
A limited
palette
page 9

3
Choosing
colors
page 9

4
Selecting
pastels
page 10

5
Buy the
best
page 10

6
An improvised
storage box
page 10

7
Finding the
right color
page 11

8
Keeping
pastels clean
page 11

9
Cleaning
dirty pastels
page 12

10
Setting up a
work station
page 12

11
An improvised
palette
page 13

12
Keeping your
work clean
page 13

13
Advice on
boards
page 14

14
A homemade
color chart
page 14

15
A perfect
surface
page 14

16
Work hard
to soft
page 15

17
Smudge-free
paintings
page 15

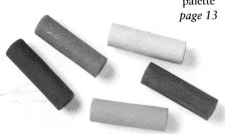

INTRODUCTION

HAVE YOU EVER looked at a pastel painting in a gallery and wondered how a particular effect was achieved? Or watched an artist demonstrating a technique that suddenly opened up new possibilities? Have you despaired of a pastel because the colors look too bright or too dull, and you don't know how to save the situation? Or, on a more mundane level, have you perhaps gone out sketching and found that you have the wrong color of paper? Even professional artists have frustrations and near-disasters, but they learn to overcome them, and so will you with the help of *100 Keys to Great Pastel Painting*. The book is not intended to be a full course in pastel painting, but is a collection of fascinating nuggets of advice drawn from the experience, problem-solving abilities, and working methods of many artists.

Pastel is a wonderfully direct and expressive medium, combining the virtues of paint – pure, glowing color – with the handling properties of the drawing media. With a stick of hard or soft pastel, or of oil pastel, for example, you can draw as you would with a stick of charcoal, but you can also spread, blend, and overlay colors to build up thick, painterly effects. There are so many different ways of working in pastel that it is impossible to lay down a set of rules, but, once you know what can be done,

you will be halfway to finding your own style.

The keys in the book are divided into sections for easy access to the kind of information you need. Turn to the first sections for general advice on colors and papers, for instance, and to later ones for help with specific techniques and effects, including ways of "saving" a picture that has not quite worked. You will learn how to tint your own paper (did you know that you can do this with a used teabag?), how to create textured effects by working over an acrylic ground, how to turn oil pastel into paint by spreading it with mineral spirits, how to combine pastel with other media such as paint and charcoal, and many other invaluable techniques. There is a short section on erasing (always a problem in pastel work), some hints for the traveling artist, and a section on caring for your work. Pastel is a fragile medium, and your pictures won't last unless you look after them.

100 Keys to Great Pastel Painting is a book for dipping into when you need advice, inspiration, and encouragement. With the book in hand, look back at some of your finished pastel paintings and see whether a different method might have improved them. If you find any of the keys particularly inspiring, try them out – you will learn a lot simply by experimenting with the medium, and you will enjoy yourself in the process.

This book is highly recommended – you might even want to buy two copies, so that you have one on hand to lend to a painting friend.

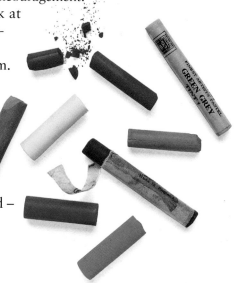

MAKING A START

This section combines practical advice on pastel types and colors with some more unusual hints. Did you know, for example, that you can clean your pastels with ground rice? Had you thought of using supermarket vegetable trays as "palettes" to hold the selection of pastels you will need for each picture? These are just two of the many helpful keys that you will find on the following pages.

1 **A BASIC PALETTE** To build up a selective yet versatile palette, buy one cool and one warm version of the most important colors in the spectrum. Basic cool colors include poppy red, lemon yellow, olive green, cobalt blue, and burnt sienna. Useful warm colors include crimson lake, cadmium yellow, viridian, French ultramarine, and burnt umber. To broaden your palette, supplement these colors with black, white, and a few earth tones such as madder brown and raw sienna.

POPPY RED TINT 8

LEMON YELLOW TINT 2

OLIVE GREEN TINT 7

COBALT BLUE TINT 4

BURNT SIENNA TINT 8

CRIMSON LAKE TINT 8

CADMIUM YELLOW TINT 6 (Hue)

VIRIDIAN TINT 4

FRENCH ULTRAMARINE TINT 8

BURNT UMBER

2 **A LIMITED PALETTE** If you want to try out pastels using just a few colors, select your initial palette to suit your favorite subject. If you paint landscapes, for instance, choose a wide selection of greens, but if you paint portraits, you will need a range of flesh tones plus a few extra colors for the sitters' clothing. Add to these a selection of neutral colors for creating highlights and shadow areas.

3 **CHOOSING COLORS** Avoid ending up with superfluous colors by buying pastels selectively. Although you can choose a boxed set of colors that is specially put together for a specific subject – portrait, landscape or still life – there is a real danger that some of the colors supplied in it will be superfluous to your needs. If you select individual colors, you will have a more versatile range.

(Above left) Cool versions of the basic colors.
(Left) Warm versions of the basic colors.
(Above) Black and white are useful additions to the palette.

9

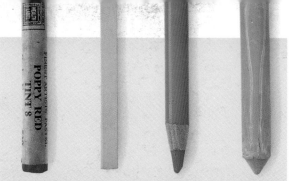

4 **SELECTING PASTELS** There are four types of pastels – bear in mind the following characteristics when making your choice. *Soft:* crumbly, vibrant; use to blend, smudge, and cover large areas. *Hard:* less crumbly, easily erased; use for preliminary drawing and detail. *Pencil:* clean, does not crumble or smudge easily; use for intricate work and crosshatching. *Oil:* does not crumble, makes buttery marks; do not mix with other pastels.

5 **BUY THE BEST** If you want to make sure that your paintings retain their brightness and freshness of color over the years, always use the best-quality pastels in your work. Even though cheap pastels are available, the greater amount of chalk, and therefore clay content (used to extend the pastel mixture), reduces the lightfastness of the pigments and will cause the colors to fade over time.

6 **AN IMPROVISED STORAGE BOX** If you do not have a readymade pastel box to keep your pastels in, try using corrugated cardboard to line boxes or drawers to keep pastels apart from each other and therefore clean. Plastic containers with separate compartments also make good "paintboxes."

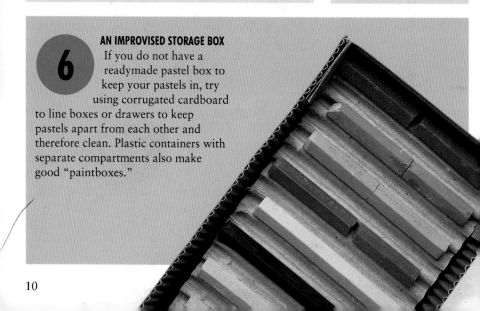

7 **FINDING THE RIGHT COLOR** If you have a wide selection of pastels, it is essential to store them in separate containers according to color: greens in one, reds in another, and so on. When working, you will easily be able to see your tint options across a color and select those that are most appropriate.

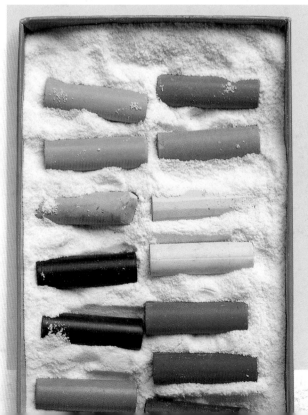

8 **KEEPING PASTELS CLEAN** If you store all your soft pastels in one box, line the box with ground rice, because this will help to keep the pastel sticks apart. The slightly rough-textured rice will also rub against the pastels, removing dust that they have picked up from other sticks and keeping them clean. Remove the pastels from the box and clean off any particles of rice before use.

9 **CLEANING DIRTY PASTELS** If your soft pastels have acquired a film of gray dust, as they quickly do, you can clean them by placing them in a large plastic bag together with enough ground rice to coat the pastels. Shake the bag well, and then pour the contents into a sifter. The dirty ground rice will fall through, leaving sparkling-clean pastels.

10 **SETTING UP A WORK STATION** If you have trouble keeping your pastels orderly while working, establish a special place for them. An old television table, serving trolley or occasional table all make excellent pastel work-tables. You should be able to pick up one of the above cheaply from a junk shop. The important thing to look for is a raised rim around the edge of the trolley or tabletop, which will prevent the pastels from rolling off. The shelf below will hold corrugated boxes, fixatives, sprays, rags, paper towels, torchons, and so on.

11 **AN IMPROVISED PALETTE** Most supermarkets and delis now sell vegetables in small plastic trays. Do not throw away the trays, as they make ideal, lightweight, easy-to-hold palettes in which to keep the particular pastels that you are using for a painting.

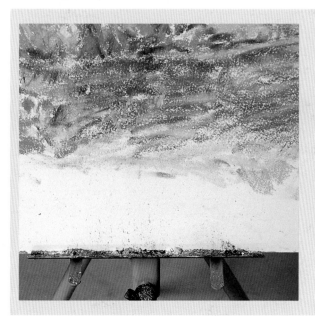

12 **KEEPING YOUR WORK CLEAN** To prevent crumbles of soft-pastel residue from collecting over your painting surface when working, work on a slight tilt or with the board held vertically on an easel. Loose powder will then fall away from the paper onto the table or floor, and can be removed with a vacuum cleaner.

13 **ADVICE ON BOARDS** Make sure that your drawing board is wider on all sides than your paper, as this will improve the way that you work. If the board is the same size as your paper, it will cramp the composition, and you will tighten your style to counteract the effect. The board can also act as a "frame" for the picture, enabling you to judge the proportion and scale correctly.

14 **A HOMEMADE COLOR CHART** If you think you will want to remove the wrappers from pastels while you are working, thus losing the color and tint information that is given on them, make a chart of the colors you are using before you start. Lay down a patch of each color along the edge of a piece of paper, and write the color name and tint beside it. You can then identify a color you have used in a painting by overlapping the edge of your chart with the relevant color in your work. You can also use the chart to identify pastels which have lost their wrappers.

15 **A PERFECT SURFACE** If imperfections appear on the surface of your work, they could well be caused by the texture of the ground under your paper. Any pit, bump or cut-line on the board under your paper will be picked up by the pastels in a "brass-rubbing" effect. To avoid this problem, cushion your pastel paper with layers of acid-free paper attached between it and the board on which you are working. This will give you a smooth, soft surface on which to work.

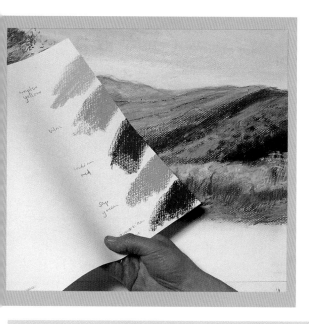

16 WORK HARD TO SOFT If you have both hard and soft pastels, start working with your harder pastels. Resist the temptation to start with ultrasoft pastels, as they will clog the paper and make later adjustments difficult.

17 SMUDGE-FREE PAINTINGS To avoid smudging your pastel painting with your hand as you work, become accustomed to working from left to right if you are right-handed and from right to left if you are left-handed, and from the top of the paper down. In this way, you will always be resting your hand on clean paper and will not accidentally disturb the work already done. If it is not practical to work methodically across the paper, you can cover completed areas with a sheet of paper and rest your hand on that while working on the next area.

PAPERS AND GROUNDS

The "standard" papers sold for pastel work, which come in a wide choice of colors, are adequate for most needs, but there are many other kinds of paper with which to experiment. Sandpaper, for example, is a favorite with many artists, as is watercolor paper, which you can tint with water-based paints in any color you choose. If you like a good texture to work on, you can also lay a special ground with acrylic paint or gesso.

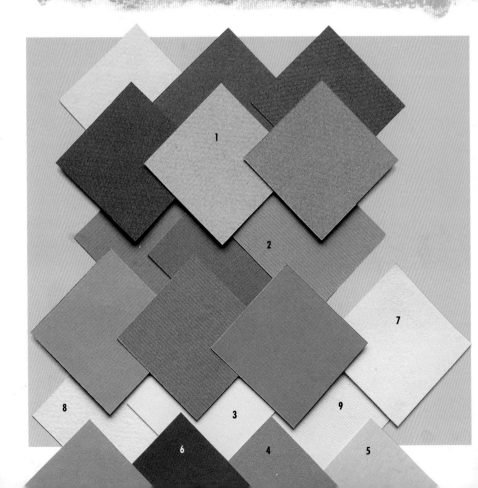

18

PAPERS FOR SOFT PASTEL If you have trouble with soft pastel not adhering, you may be using the wrong surface. Soft pastels adhere best to paper with some "tooth," as the particles are held in the texture.

1 Mi-Teintes paper has a textured surface resembling fine chicken wire. The "wrong" side has a different texture and can also be used. Mi-Teintes is tough and therefore ideal for heavily worked pastel.

2 The "laid" surface of Ingres paper consists of close parallel lines. It comes in a choice of colors, from pale neutrals to stronger and darker tones, or with a fleck, which gives a mottled effect to the surface color.

3 "Not" watercolor paper is a popular choice. It is only produced in white, but can easily be tinted with watercolor, acrylic, or a dry wash of pastel (see Tip 30).

4 Velour paper has a coating of powdered cotton. It holds pigment particles well and is a good choice for heavily worked paintings.

5 Flour paper is ideal for pastel work, but is only sold in small sheets.

6 There are two types of sandpaper suitable for soft pastel. Artists'-quality sandpaper is a neutral color and comes in large sheets. Wet-and-dry sandpaper can take a wash, but is only available in small sizes and is black in color. Use the finest grit (400) for pastel work.

7 Pastel cloth is a synthetic fabric backed with fiberglass for strength. It absorbs underpainting much like paper, but does not buckle when wet.

19

SURFACES FOR OIL PASTEL Oil pastel does not fall off the paper as soft pastel does, but if you want to build up colors thickly, a textured paper will give the best results.

1 Mi-Teintes paper is well suited to oil-pastel work. Either the "right" (textured) side or the "wrong" (smoother) side can be used. This paper is fairly tough and will allow you to spread the oil pastel with mineral spirits and manipulate the color without harming the paper. Use mineral spirits, not turpentine, however, as the latter is slightly oily and may rot the paper over time.

2 Ingres paper can also be used. Although it is thinner than Mi-Teintes, the surface is not easily damaged and will allow manipulation of the color with mineral spirits.

8 Watercolor paper, either smooth (Hot-pressed) or medium (Not surface) is a good choice for oil pastel. If you don't like working on white paper, you can tint it with a wash of oil paint thinned with mineral spirits, or with acrylic diluted with water.

9 Oil-sketching paper, which has a texture resembling canvas, is ideal for "painterly" approaches in oil pastel. It is very strong and allows you to combine a variety of brush and line techniques. Any mistakes can be quickly corrected, simply by wiping off the color with mineral spirits.

20 **AVOIDING DISCOLORATION** If you want your work to last, use an acid-free paper, as this will not disintegrate or discolor with age, or cause the colors of the pastels to change over time.

21 **A CHOICE OF SURFACES** Experimenting with different paper textures will help you to achieve varied effects in your work. Ingres paper, shown below, has one slightly textured and one smooth surface. Mi-Teintes paper also has two surface options.

22 **PAPER ALTERNATIVES** If you cannot obtain standard pastel papers, construction paper or recycled paper make good alternatives, although the colors may fade in time if the paper is not acid-free.

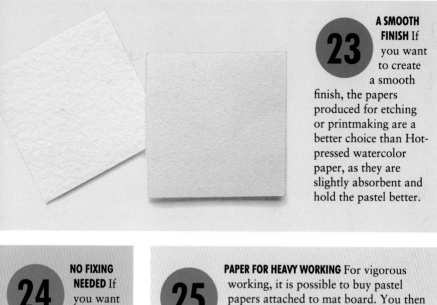

23 **A SMOOTH FINISH** If you want to create a smooth finish, the papers produced for etching or printmaking are a better choice than Hot-pressed watercolor paper, as they are slightly absorbent and hold the pastel better.

24 **NO FIXING NEEDED** If you want to avoid fixing your work, use a paper with a good tooth. The better the paper grips the pastel, the less it will need fixing.

25 **PAPER FOR HEAVY WORKING** For vigorous working, it is possible to buy pastel papers attached to mat board. You then have all the advantages of a paper surface ready-stretched on a rigid ground.

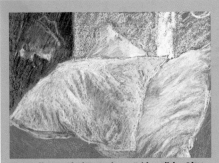

In "Yellow and Blue Cushions" (detail) by Olivia Thomas, the paper color contrasts with the pastels.

26 **A LAST RESORT** If you have nothing else, you can use brown wrapping paper as a cheap alternative to pastel paper. See the pastels of Venice by James McNeil Whistler (1834–1903) for proof of this! Be careful, though, as the paper is unlikely to be acid-free and is best reserved for pastel sketches and rough work.

27 **SETTING UP A CONTRAST** Most pastel painters like to use a paper which tones with the overall color scheme of the subject, but an alternative approach that can be exciting to try is to use an "opposite" color for the paper. For example, if you paint a snow scene or a predominantly blue-gray landscape on warm yellow or brown paper, it will provide a color contrast from the start. If small patches of the paper color are allowed to show through in the finished painting, they will enhance the blues and grays.

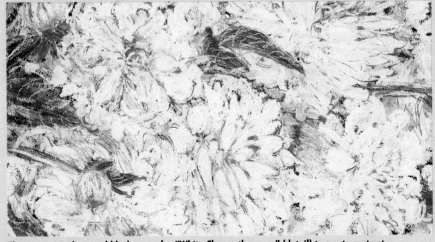

The same artist has used black paper for "White Chrysanthemums" (detail) to create contrast.

In "Autumn Colors at Chiswick House," also by Olivia Thomas, blue paper gives additional brilliance to the yellows and oranges.

28 **COLORED PAPER** If your pictures appear dull in color, or convey the wrong mood, try working on different-colored papers. Colored paper can be left uncovered in places, which means that you do not have to put on so much pastel. A gray sky, for example, might consist almost entirely of the paper color.

29 **CHANGING THE GROUND COLOR** If the paper color that you have is not what you want, and provided that the paper is thick enough, you can alter it with a wash of watercolor or acrylic paint. In doing this, stretch the paper first to prevent it from buckling.

30 **LAYING A PASTEL GROUND** You can also change the color of the paper, or lay a tint of your choosing on watercolor paper, by putting down what is known as a dry wash. This is very simple; all you do is scrape a soft-pastel stick with a sharp blade until you have a good quantity of colored dust and spread this over the paper with a rag or piece of absorbent cotton. Fix the wash before working over it. If required, you can make the color darker in some places than others, or even use different colors. In a landscape, for example, you might lay a blue or gray dry wash for the sky area and a yellow or brown one for the land.

Three colors of pastel have been used here, providing base tints for both sky and land.

31 **UNUSUAL TINTS** If you are using watercolor paper and would like to tint it in an unusual manner, follow the Chinese example and rub damp tea leaves across the paper surface – or you could gain the same effect by dabbing with a used teabag! Coffee also makes a good stainer.

32 **RETAINING THE TOOTH** If you tint the paper with acrylic, be careful not to apply it too thickly and smoothly, as it will impair the surface tooth, making it more difficult for the pastel to adhere.

33 **A CHARCOAL GROUND** Scene painters' charcoal on watercolor paper makes an interesting colored and textured background, and mixes well with soft pastels. Blend it into the paper, and then brush off excess dust before applying pastels.

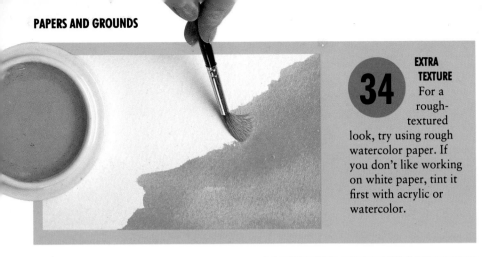

34 **EXTRA TEXTURE** For a rough-textured look, try using rough watercolor paper. If you don't like working on white paper, tint it first with acrylic or watercolor.

35 **A TEXTURED GROUND** For another way to achieve a rough-textured look, try laying a ground of acrylic gesso or acrylic modeling paste on smooth, heavy watercolor paper. Apply it in roughly diagonal or multidirectional strokes with a large bristle brush. The texture of the brushmarks will be visible through the overlaid pastel, giving an extra quality of movement to the finished painting.

Acrylic modeling paste is laid with a household paintbrush.

The pastel color catches on the ridges.

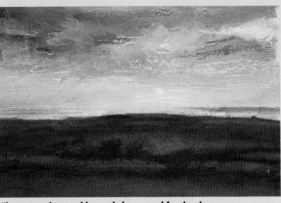

The textured ground has only been used for the sky area.

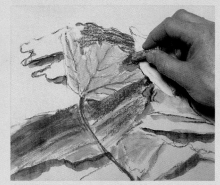

Diluted black ink is applied with a brush.

It is allowed to dry before pastel is used.

36 DARK DARKS If you find it difficult to establish dark values because the dark colors you want to use are not available or seem to dull your work, try washing in the darks with a different medium, such as diluted ink or very thin acrylic, when you begin the painting.

The red-brown pastel over the ink creates a rich brown.

37 ELIMINATING SPOTS The slightly rough texture of heavy watercolor paper breaks up the pastel strokes, and you may find that small, unwanted white spots remain across the surface when the painting is complete. If you give the paper an initial watercolor or thin acrylic wash in a color that is harmonious with the subject before you start, however, any spots not covered by pastel will be unnoticeable.

PREPARATORY DRAWINGS

One of the problems with pastel work is that you cannot erase easily, so you need to begin with a good drawing. But how do you make this drawing? Ordinary pencil is not suitable for use under pastel, but you can use charcoal or pastel pencil, and there are several other useful methods, too, such as pouncing and tracing, which are ideal for intricate and complex designs.

38 **UNDERDRAWING** Don't make preliminary drawings for soft-pastel paintings with graphite pencil, as it is slightly greasy and repels the pastel pigment. Instead, use hard pastel, a pastel pencil, or charcoal.

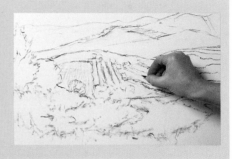

39 **TRACING THE IMAGE** If you feel that you need to make a detailed sketch in pencil on your pastel painting from which to work, but are worried about the graphite repelling the pastel color, try tracing the original sketch on pastel paper. To do this, first draw the detailed sketch on a piece of typing paper, and then trace it using a 2B pencil. Go over the sketch on the reverse of the tracing paper with a 2B pencil. Then place the tracing paper with the right side up over the pastel paper and transfer the sketch. This takes a little extra time, but it will keep your paper in pristine condition and will give you a pale yet detailed sketch to work over that will not affect the pastel's adhesion to the board.

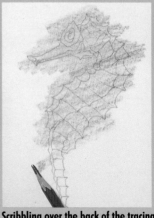

Scribbling over the back of the tracing.

40

POUNCING Another way of transferring an image is pouncing, which is most suitable for small-scale work involving a complex design. Prick holes all along the lines of your original drawing with a long needle, an awl or similar implement, then lay the drawing on the pastel paper and push powdered pastel through the holes by rubbing it over the surface with a soft rag or piece of absorbent cotton. This produces faint dotted lines, which you can strengthen if needed by drawing over them with a pastel pencil of the appropriate color.

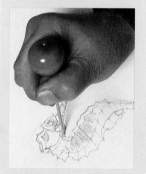

First the tracing is pricked with an awl.

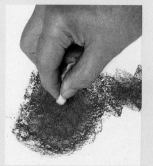

Soft pastel is rubbed through the holes.

The dots are easy to follow.

Using a hard pencil to transfer the lines.

The lines will be faint but clear.

41 WHITE-LINE DRAWING

Interesting effects can be achieved by indenting the surface of the paper and then laying pastel on top, so that the indentations show as a series of white lines. Watercolor paper is best for this, as it needs to be fairly tough. Either draw "blind" onto the paper with an implement such as a knitting needle, or draw the design on tracing paper first, place it on the paper, and go over the lines with a hard pencil or ballpoint pen.

A ballpoint pen makes clear indentations.

The indented lines show up white.

42 SHADOW AREAS

If you are creating a preliminary sketch with charcoal, light crosshatching in the shadow areas makes useful reference for later stages of the work. Remember to brush off any excess charcoal dust or to spray on fixative before starting to apply pastels, to avoid contamination.

CHARCOAL DRAWING

43 Charcoal is a good medium with which to create your initial drawing, as its texture complements the pastel medium. Once you are ready to apply pastels, flick the drawing with a rag, and most of the charcoal will fall away, leaving you with a light "ghost image" from which to work.

44 **ENHANCING SHADOWS** Dark colors can be difficult to achieve in soft pastel, so, to enhance the shadow areas in the composition, try making your initial sketch in black ink. Before it is completely dry, smudge it slightly and then begin applying pastel, allowing the ink to smudge further with it.

The ink is used undiluted to give a strong black.

Water makes a middle tone, and then pastel is applied.

SPECIAL EFFECTS

The keys in this section will help you to develop your own pastel style by experimenting with different techniques. Not only will you discover how to create subtle shades by blending or dragging colors, but you can also try out some more unusual ways of working, such as wet brushing, and sgraffito with oil pastel. There are also hints on how to rescue areas that may have become tired or overworked.

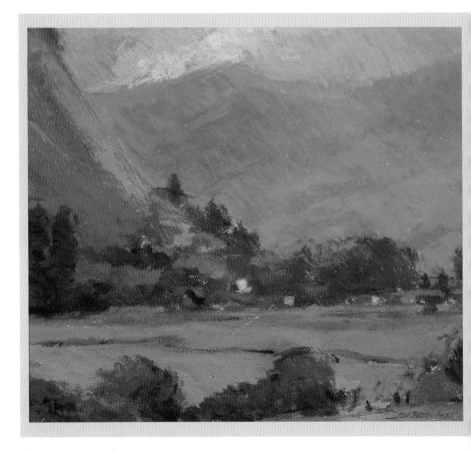

HARD PASTEL OVER SOFT

46 When you plan to use hard pastel or pastel pencils in the later stages of a soft-pastel painting, avoid a heavy buildup of soft pastel in the initial stages, as the hard pastel will not adhere over it and will also remove earlier working.

FEATHERING

45 If you have over-blended a color when working in soft pastel or oil pastel, and it has lost its vibrancy, feathering can rescue the situation. Make quick linear strokes across the overblended areas in either a lighter or darker color.

In "Outside Jackson Hole," Doug Dawson has used a version of feathering for the sky and mountains.

TONING DOWN COLORS Feathering can also **47** be used to "knock back" a color that is too bright. For example, if a red looks too fiery, you can modify it by feathering over it with its complementary, green. This technique works best with a hard pastel or pastel pencil, but if there is already a thick buildup of pigment, you may have to use soft pastel.

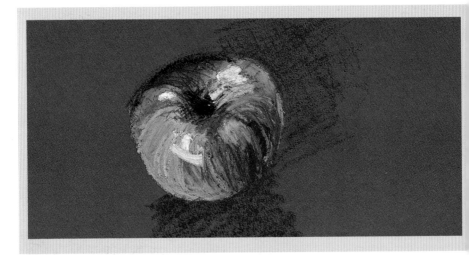

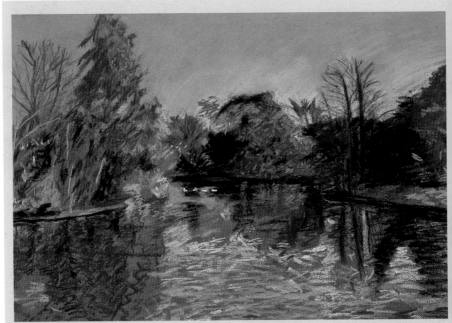

Suzie Balazs has reserved the strongest strokes for the foreground in "End of Autumn, Dulwich Park."

48 **SOLID FORMS** Do you have the problem of three-dimensional forms looking flat? If so, your strokes are probably too straight. Curved strokes which follow the form (known as bracelet shading) will reinforce the illusion of solidity.

49 **SPACE AND DEPTH** If your paintings appear too flat, you may be using uniform marks across the entire painting surface. If this is the case, try using vivid, more definite strokes in the foreground and softer, smaller, less well-defined marks in the distance. This will greatly enhance the illusion of depth.

"Celebration" (detail) by Urania Christy Tarbet.

50 **EXTREMES OF LIGHT** If you want to create areas of bright light or deep shadow in a painting, make sure that your marks are softened and blended.

51 **A LIVELY SURFACE** If your work seems dull and lacking in expression, you may be applying your pastel strokes too consistently, in similar lengths and directions. Vary the direction of your strokes to counteract this.

Lightly scribbled strokes, laid over side strokes.

Diagonal strokes give movement to the trees.

52 **EMPHASIZING A FOCAL POINT** To make a focal point – the center of interest – more powerful, render it in strong, definite strokes and surround it with softer strokes.

In Gary Michael's "Scholar," the lively use of marks not only describes texture but also means that the face is the center of interest.

53 **CREATING UNITY** If your work appears somewhat choppy, it could be because all your strokes vary in length and direction. For the most interesting effects, vary your strokes, but repeat each type enough to give a sense of overall consistency.

In "Afternoon, Ville Fagnan" by Debra Manifold, the marks are all of the same kind, although there is variety within the overall unity.

54 **POINTILLIST COLOR** If you have trouble creating a sense of depth or good tonal variation when blending pastels on the paper, take a look at the works of Jean Édouard Vuillard (1868–1940), Odilon Redon (1840–1916), Pierre Bonnard (1867–1947), and Henri Matisse (1869–1954) for examples of the pointillist technique of color mixing. The color is not always blended in their work. Instead, it is applied as individual colors in dots and dashes over the paper, and the colors mix in the eye of the viewer to create interesting surface textures and color vibrations.

55 **QUIET COLORS** As the range of neutral mid-toned colors is limited, it can be difficult to achieve successful subtle colors and "low-key" effects in soft pastel. Try using charcoal hand-in-hand with pastel wherever you want to "knock back" the colors. In a landscape, for example, the gray-greens and blue-greens seen in the middle distance can often be achieved by laying a light veil of charcoal over pastel color. Alternatively, block in the area with charcoal first, but don't fix it; this way, you will be deliberately "polluting" the pastel color laid on top.

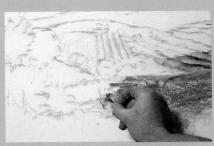

Charcoal can be used under or over soft pastel.

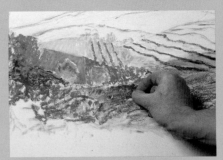

The two media blend together very well.

56 **CROSSHATCHED COLOR** To create crosshatched effects, hold the first pastel color as if it were a pencil and make quick strokes in one direction. Then use the second color to make marks over and roughly at right angles to the first; Always apply the stronger color first, otherwise, the overlapping color will obliterate the color underneath. For instance, if you apply pale green and then put down strong blue over it, the green will disappear.

57 **DRAGGED COLOR** When dragging one color over another, put down the first color with firm pressure, and then drag the second color across it very lightly, using the side of the stick. This creates a light veil of color, which modifies the original one while leaving it partially visible.

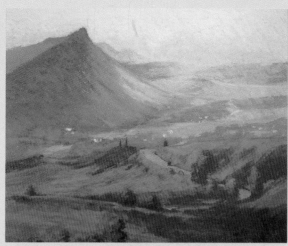

In "View Over Morrison," Doug Dawson makes extensive use of dragged color, particularly in the distant mountains.

58 **WET-BRUSHED COLOR** Soft pastel consists almost entirely of pure pigment, so it can be spread with water in a very similar way to powder paints. A technique that is often used either to soften pastel strokes or to cover large areas of the paper quickly is wet brushing, in which a soft brush is dipped into clean water and then washed over the pastel. This can create attractive effects in a painting, as it releases some of the color to form a watercolor-like wash, while leaving the pastel strokes intact.

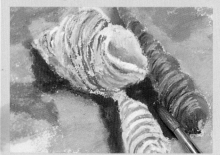
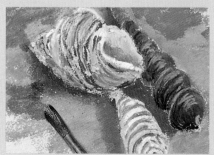

Soft pastel is almost pure pigment, which is released and spread by adding water.

59 BLENDING SOFT PASTEL

If you want to achieve a smooth effect in a painting, or subtle gradations of tone and color, blending is the answer. For large areas, lay the pastel down lightly and then rub over it with a rag or your hand. Several colors can be laid one on top of another and blended to produce a mixture on the paper surface. For smaller areas, the traditional blending implement is a torchon – a tight roll of paper made for the purpose (see Tip 67) – but you can also use cotton swabs. Remember that you will not be able to blend to any great extent on sandpaper or velour paper.

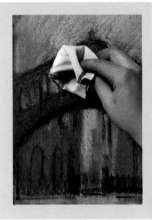

60 BLENDING OIL PASTEL

Oil pastels cannot be rubbed into each other as easily as soft pastels, but you can blend just as successfully if you "melt" the color with mineral spirits. For large areas, lay down the colors and go over them with a brush or rag dipped in mineral spirits. For smaller areas, use a spirit-moistened small brush, a cotton swab, a torchon, or your finger.

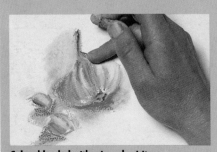

Colors blended with mineral spirits.

Soft gradations of tone can be achieved.

61 **SHARP EDGES** It can be difficult to create sharp edges with pastel, as it smudges so easily. There are various ways of dealing with this. One good technique is to work on the color areas on each side of the edge simultaneously, pushing the colors up against each other.

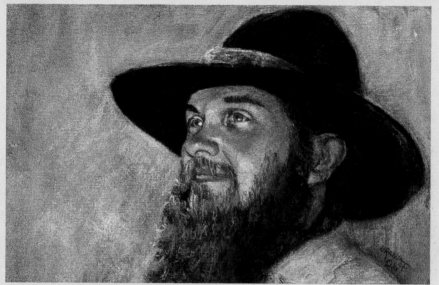

For "The Sod Buster" (detail), Urania Christy Tarbet has worked on canvas to reduce smudging.

62 **CLEAR OUTLINES** You can use the edge of a sheet of paper as a mask while you work. Lift the paper up carefully to avoid disrupting the outline once you have applied the necessary pastel.

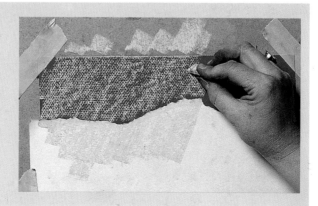

63 PENCILS AND STICKS
Pastel pencils cut to very sharp points, used in conjunction with pastel sticks, are very good for emphasizing sharp edges and adding definition to outlines.

64 SHARPENING SOFT PASTELS
It is possible to make fine lines with soft pastels, either by breaking a stick in half and using the side of the broken edge, or by sharpening the tip itself by rubbing it gently on a piece of sandpaper. Leave this kind of fine-line detail to the last stages of a painting, or there will be a risk of smudging.

65 PENCIL TECHNIQUES If you have trouble creating crosshatching or feathering with sticks of soft pastel, try using pastel pencils or hard pastels in these areas. Because of their length and resistance to snapping, they give you greater control, and your hands stay clean!

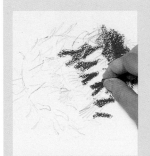

The layers of oil pastel are applied.

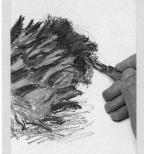

The point of a mat knife makes very fine lines.

The effect varies with the pressure applied.

66 **SGRAFFITO EFFECTS** In oil pastel, highlights and various color effects are often achieved by scratching into one color to reveal another one below. The method involves covering the paper, or a selected area, with a solid layer of color, well rubbed into the paper grain, before laying another on top. This also needs to be quite heavy, but should not be rubbed in. Any sharp implement can then be used to draw or scrape into the top layer of color. A fine point, such as the tip of a mat knife, will obviously give fine lines, but you can also achieve interesting broken-color effects by scraping gently with the side of a knife, which removes the color from the top of the grain only. The method can also be used in soft pastel, but you must work on a solid surface, such as pastel board. Make sure that you fix the first layer of color before putting on the second.

Sgraffito is ideal for a delicate subject which needs fine lines.

67 **HOMEMADE TORCHONS** Try making your own torchons for blending detailed areas. Take a toothpick and a small piece of paper towel. Soak the towel in water and then roll it around the stick, without letting the paper protrude too far beyond the points of the stick. The paper will shrink as it dries to form a tight covering, without the need for any further adhesion. When the torchon becomes dirty in use, simply pull off the paper and re-use the stick. Homemade torchons can be used dry with soft pastels, or dipped in mineral spirits or turpentine to blend details in oil-pastel paintings.

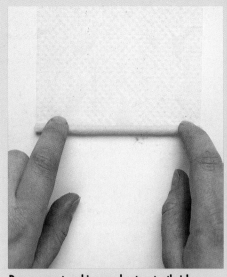

Damp paper towel is wound onto a toothpick.

68 **SOFT - FOCUS EFFECTS** To create very soft, out-of-focus paintings, you can blur the outlines of images using your finger, a tissue, or a rag. Edouard Manet (1832–83) did this to create the impression of out-of-focus photographs, which were in vogue at the time.

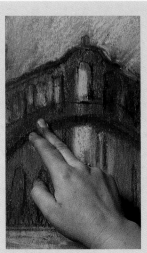

Unwanted edges can be softened with a finger.

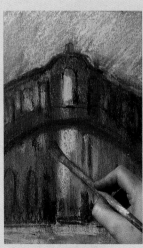

For larger areas, a bristle brush or rag can be used.

The homemade torchon used for blending.

69 **CREATING TEXTURE** To achieve a textured effect, perhaps for distant clumps of trees, dab into soft pastels with a fingertip or small cotton ball. For a more pronounced effect, dip your finger or the cotton ball into water first. The same method can be used with oil pastels, but with mineral spirits instead of water.

70 **APPLYING DETAIL** When applying details over pastel work which has used up the grain of the paper, the additional pastel will not adhere. To overcome this, try dipping your pastels in water and working over the top quite heavily.

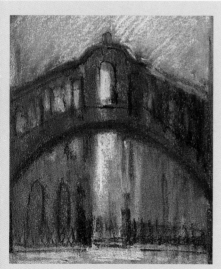

The overall effect is gentle and atmospheric.

71 **FIXATIVE AS MEDIUM** To create unusual surface textures, try using fixative in a positive way and mixing it with soft pastel. You can do this either by spraying the paper and then working into it with pastel while the fixative is still wet, or by spraying existing color quite heavily and then working into it with brushes or more pastel. A more extreme approach is to dip a brush into fixative and work over pastel. Edgar Degas (1834–1917) used to make a kind of paste with his pastels in a similar way, although no one is sure of his precise methods.

A tailor's steamer wets the pastel and paper.

The damp pastel is then spread with a brush.

Having sprayed the first pastel application with fixative, further pastel is worked on top.

Mixed pastel and fixative resembles oil pastel.

72 **STEAMING THE SURFACE** Degas also invented a technique of steaming soft pastel in certain areas of a work. This created a paste which could then be worked over with a brush, extending the repertoire of possible surface textures. If you want to experiment with this, work on stretched paper so that it does not buckle when it becomes damp from the steam.

HIGHLIGHTS

Creating highlights is an important part of successful pastel painting. As pastel is an opaque medium, light colors can be laid over dark ones, so it is sometimes possible to leave the highlights until last and to concentrate on the darks first. Take care with last-minute highlights, however, particularly if you have used the pastel thickly, or the highlights may become muddied through mixing with the layers of color beneath.

73 **DARKS FIRST** Don't add light colors during the early stages of a painting. If you use the lights too freely or too soon, you will find it difficult to get the darks dark enough, and the painting will become pale and washed-out. Spend time getting shadows and mid-tones right first.

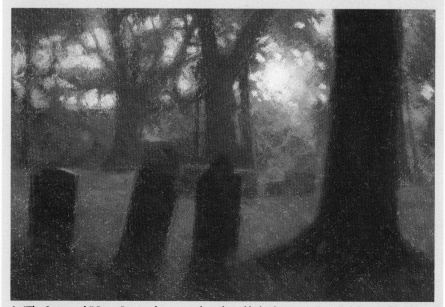

In "The Graveyard," Doug Dawson has painted patches of light sky over and around the middle tones.

HIGHLIGHTS

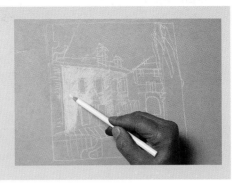

74 **HIGHLIGHTS GUIDE** If your subject has large, definite highlight areas, such as white buildings in a landscape, map them out in white pastel pencil so that you can develop them later in the work.

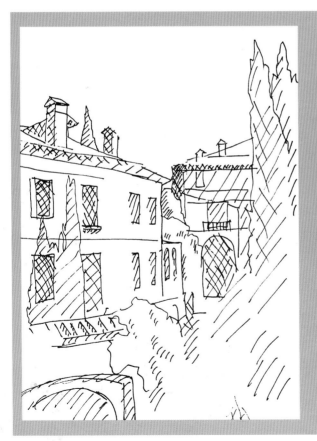

75 **CHANGING LIGHT** When working outdoors, remember that, as time moves on, the direction of the light changes, altering the highlights. Make a note of the direction of the light falling on your view before you begin, and stick to that throughout the painting. This will prevent you from producing conflicting highlights and shadows. If you have time, work on a painting at the same time over several days in order to record the effect of the light more accurately.

FIXING

There is constant argument about the use of fixative in pastel-painting circles. Some artists avoid it altogether, claiming that it spoils the freshness of the colors; some fix at regular intervals as they work, but leave the completed picture unfixed; and others fix only at the final stage. If you do like to use fixative, but find it difficult, the following keys explain how to achieve the best results.

76 **DIFFUSERS** If you use a mouth diffuser to apply fixative to a soft-pastel painting, you probably find that it clogs easily. If you pass a thin piece of wire through the diffuser after each use, this will clean the passage for the next time.

77 **NON-SPRAY FIXING** Many artists find that fixative alters the color and texture of a soft-pastel painting. An effective alternative to the use of fixative is to lay a sheet of tissue paper or cellophane over the painting, cover it with a board, and apply pressure. The pressure will push the pastel particles more firmly into the grain of the paper without affecting the surface. Be careful that you do not apply too much pressure, however, as this will alter the surface textures of the painting.

78 **KEEPING COLORS BRIGHT** If you like to fix your work, but are disappointed by the dulling effect created by fixative, spray it on during the painting process but before you add the final layer of color or highlights. In this way, the finished work will retain its freshness.

This picture is at the halfway stage, with colors laid over one another quite thickly.

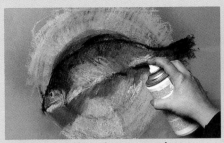

Fixative is applied in order to prevent the new colors from mixing with earlier ones.

79 **FIXING FROM THE BACK** To avoid over-spraying a painting with fixative, try spraying the back of the paper. The fixative will soak through and dampen the pastel to hold it in place, but will not disturb the surface of the work. If you are using absorbent paper, this is a better way of fixing than spraying a skin of fixative over unstable pigment.

The white can now safely be applied over the other colors.

The final colors are left unfixed to retain their freshness.

80 **PERFECT FIXING** If you consistently overspray your paintings, perhaps you are standing too close to the work. Stand at least 2 feet away from your picture and begin spraying from outside the picture plane. Work back and forth across the painting with a slow, controlled motion, always going beyond the edge of the painting before stopping. You should apply a fine, even spray, and keep your arm moving all the time so that the spray does not build up in one spot. Too much fixative in one spot will create dark patches or drip down the work.

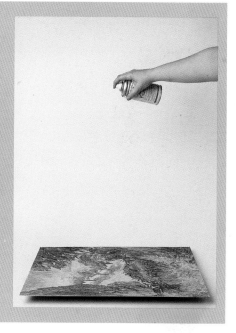

ALTERING AND ERASING

Beginners can sometimes find early attempts at pastel rather nerve-racking because they have been told that it is not possible to erase. Although it is true that you cannot rub out the marks as you would a pencil drawing, there are ways, as you will see from the keys that follow. And there really is no need to worry, because you can easily work over wrong lines and colors if you brush off the loose pigment first.

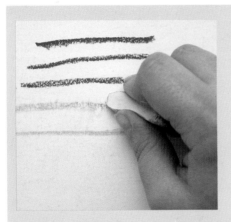

81 USING A PLASTIC ERASER

Pastel cannot be erased completely, and if you try to rub out unwanted marks with a standard eraser, you will damage the paper and lose the surface texture. However, if you use a kneaded plastic eraser in a gentle dabbing motion, you will be able to remove most of the pigment, leaving a faint "ghost" line which you can then work over.

82 ERASING WITH BREAD

A small piece of kneaded fresh white bread makes a very effective alternative to a plastic eraser.

83 UNWANTED MARKS

Try using a stiff hog brush to remove unwanted pastel marks. This makes a very good substitute if you do not have an eraser on hand.

84 RE-USING PAPER If you give up on a picture, don't waste the paper. Apply a wash of acrylic paint over the painting, allow it to dry, and you will find that new pastel will work well over it. This is only possible on papers which do not buckle, such as heavy-grade watercolor papers. The acrylic paint will mix with the pastel as you apply it, creating a tint upon which to work.

85 MINOR ALTERATIONS To make very small alterations to a soft-pastel painting without damaging the surface of your work, try making short, dabbing strokes with your finger. This does not have the same effect as rubbing the area. Alternate the direction of these strokes to mirror the direction used to apply the pastel in the first place.

86 ERASING OIL PASTEL One of the joys of oil pastel is that mistakes can be rectified very easily. Instead of an eraser, simply moisten a cotton ball with mineral spirits and wipe off the color. You can remove it quite cleanly, and the spirits will not harm the picture surface as it evaporates almost immediately.

87 **TRANSFERRING THE IMAGE** If you are happy with the structure of a soft-pastel image that you have drawn, but have overworked it and cannot rectify the errors, try a technique often used by Degas. Soak a new piece of paper in water and let it drain. Then place it firmly over your existing picture; make sure that it does not move at all once placed down. Rub the back of the paper firmly with your hand or a damp sponge. Then lift it gently off the picture, and you will have lightly transferred the image onto the new piece of paper, albeit in reverse. Tape it to a board and allow it to dry, so that the paper does not buckle. You can then start work on the image again.

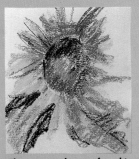

The image to be transferred is on watercolor paper.

A sheet of the same paper is placed on top and dampened.

The top sheet is lifted away from the painting.

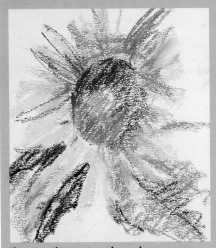

The original image is unchanged.

And a reversed version of it appears.

TRAVEL

It can be hard to decide what you will need when you are setting off to paint in a new place. The colors of the scenery may be quite different from those to which you are accustomed, so which pastels do you take, and what color paper? It is best to take the minimum – don't forget that colors can be mixed, and paper tinted. Make sure, too, that you have a supply of tissue paper to protect your work.

88 **STAYING CLEAN** Carry some wet wipes with you when pastel painting on location so that you can clean your hands whenever necessary. If you are working with oil pastels, take rags and a bottle of mineral spirits.

89 **PROTECTING YOUR WORK** When working away from home, take some acid-free tissue paper to place between your paintings to prevent them from smudging while in transit.

90 **NON-AEROSOL FIXATIVES** When traveling, you may not be allowed to take aerosol fixative on an airplane for safety reasons. Hairspray, which is now available in non-aerosol containers, makes a cheap and satisfactory alternative, or you could take a bottle of fixative and a diffuser instead.

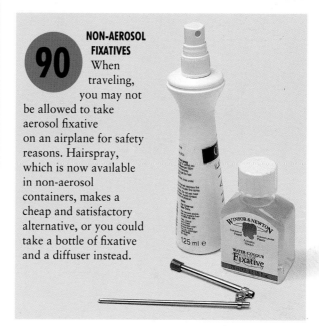

TRAVEL KIT

91 Always keep a travel set of materials ready for expeditions. This should include everything you need for working outdoors when the wind blows, including clips and masking tape. Take only the very basic range of colors. This is a good discipline and means that you don't carry unnecessary colors with you. While the exact color may not be in your box, you can always make a note to the effect that the real tone is sharper or softer, or closer to another color, for later work back in the studio.

92 **ALL-PURPOSE PAPERS** Rather than taking a large selection of papers with you when working outside, stick to one or two mid-toned neutrals which will be suitable for most subjects. If you find you need a darker or more positive color, you can alter it quickly with the dry-wash technique (see Tip 30).

STORAGE, FRAMING, AND SAFETY

Pastel paintings are fragile and can easily become smudged and dirty. If you do not intend to frame your pictures immediately, make sure that they are protected – the following keys will show you how to do this, as well as providing advice on mounting and framing. There are also some valuable hints on safety measures. Remember that some pigments can be harmful, and that pastel makes a good deal of dust which should not be inhaled.

93 CARE OF PAINTINGS To protect finished pastel paintings while they are stored, cover each with a sheet of acid-free tissue paper or tracing paper. Don't use newspaper, as the acids and residue of the printing ink could damage your work.

94 LONG-TERM PROTECTION If you are intending to store a picture for a long period of time, attach it to an acid-free board with masking tape, then place a larger piece of tissue or tracing paper over it, taping that down onto the board around the pastel painting.

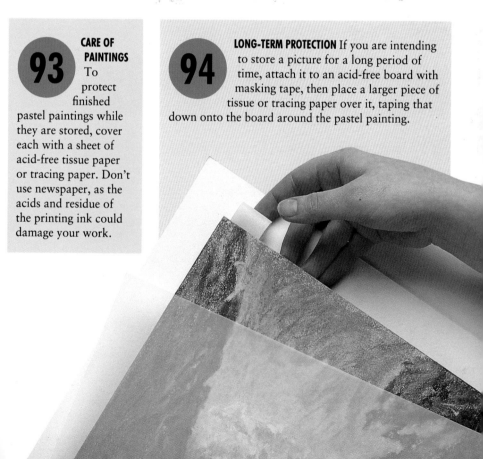

95 **FRAMING FACTS** When framing your work, it is essential to keep the pastel away from the glass with a thick mat around the picture (if the two come into contact, the moisture in the atmosphere will increase condensation on the glass, causing spots on the work). Pastel does not have to be fixed if it is to be kept under glass and will remain undisturbed for many years.

96 **SECOND THOUGHTS** Framing and mounting your work gives you a chance to reassess it and consider whether there are any minor changes that you should make. Often you can improve the composition simply by cropping: that is, taking an inch or two off the foreground or one side. This can be a simple way to "re-compose" a picture that is over-symmetrical or unbalanced. Before you measure and cut the mat, make two corners of mat board or thick paper and move them around on the painting to see whether cropping will help the composition.

97 **FIXATIVE SAFETY** To avoid inhaling fixative fumes, which can be harmful, either make sure that the room in which you are spraying is well-ventilated, or, better still, spray your paintings outdoors.

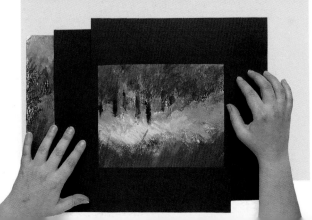

99 **SAFE PRACTICE** Manufacturers are careful to avoid the inclusion of the most toxic pigments in pastel colors, because of the risk of absorption through the skin. Nevertheless, it is wise to reduce the chance of transferring pastel colors from your hands to your mouth by making sure that you keep your hands as clean as possible when working. Always clean them thoroughly whenever you take a break.

98 **A DUST-FREE ENVIRON-MENT** If your nose becomes congested when using soft pastel, you need to improve the air ventilation in your studio. An air-filter machine is a sensible option. Pastel makes a lot of dust, and the disposable filter can become clogged very quickly. If you are seriously allergic, try wearing a protective ventilation mask over your mouth and nose, such as those worn by cyclists. This will enable you to breathe freely while it filters pastel dust from the air.

100 **FIXATIVE RECIPE** Fixatives can be toxic or inflammable. To avoid these health-and-safety dangers, try making your own ozone-friendly solution. It is very easy to do. For a clear, non-staining, permanent fixative, dissolve half a teaspoon of gelatin powder in 2 pints of hot water. Leave this until it is lukewarm, then apply it immediately to a painting with a brush or spray. If the mixture is allowed to cool, it will begin to set.

LANDSCAPES

Nature presents such wide variations of color – particularly greens – that you will need to exercise your color-mixing skills when painting the landscape. Make the paper color work for you, too, or create exciting effects by starting with an underpainting.

LANDSCAPE COLORS It can be difficult selecting from the wide choice of greens available, especially if you work in landscapes. You can, however, produce many variations on green without ever using green pastels, by mixing on the picture surface. Try a limited palette of lemon yellow, deep yellow, and yellow ocher mixed with Prussian blue, cobalt blue, and French ultramarine. These color combinations will offer you at least nine shades of green.

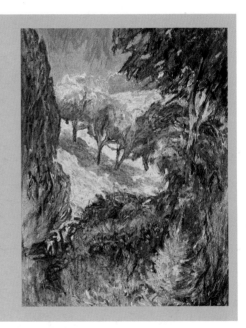

SHADOW COLORS The colors that you use for shadows will depend on the subject of your painting. However, if you want to achieve a sense of coolness in a landscape scene, you could try a technique used by the Impressionists, and choose blues or mauves for shadow areas.

Mauve is laid over other colors for shadows.

UNDERPAINTING FOR INTENSITY Do you feel that your pastel landscapes look lightweight, and not rooted in the nature that they are attempting to convey? If so, try starting with an underpainting in either acrylic or watercolor. For example, when painting a traditional landscape scene, begin by painting a loose wash of blue watercolor where the sky will be, a darker tone of brown where the trees on the horizon will be situated, and a loose wash of green for the landscape. When this is dry and you come to apply your pastel, the colors will appear far more intense than before.

Acrylic is used to make a vivid underpainting which will set the key for the picture.

Applying the acrylic thickly also provides texture.

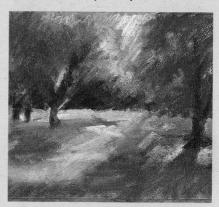

Colors must be chosen with the finished effect in mind.

UNDERPAINTING FOR OIL PASTEL If you are working in oil pastel, you don't have to use a different medium to make an underpainting – spread the oil-pastel color with mineral spirits and a brush or rag to produce a series of washes. You can then work over these with linear strokes of the pastels used "dry."

WORKING FROM A PHOTOGRAPH If you are working on a landscape painting indoors, try using a black-and-white photograph as your reference. Whereas a color photograph will tempt you to imitate or copy the colors, a black-and-white one will offer tonal suggestions while leaving room for your own color interpretation.

A dry wash has been laid over the sky area, and the composition is mapped out in line.

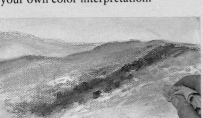

Colors are lightly blended with a rag.

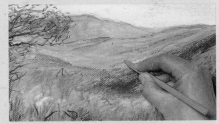

A pastel pencil is used for delicate lines.

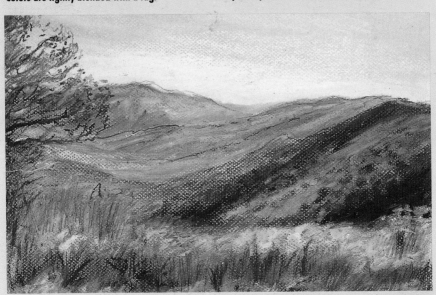

The photograph has provided the basic composition, but the colors spring from memory and imagination.

PORTRAITS

Although a variety of colors can be discerned in skin, they are all very closely related. Start with a good drawing in pastel pencil or charcoal, keep to a limited range of colors, and choose a paper color that will stand in for the middle tones or shadows.

SKIN TONES Skin tones are difficult to master, and if you start off with too wide a palette, you will quickly run into difficulties. Much more can be done with a few colors than you might realize. The first step is to identify the main color of the person's skin. If you block this in lightly, you can then bring in lighter and darker colors for shadows and highlights.

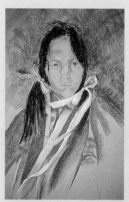

In "Spring Blossom" by Urania Christy Tarbet, the skin tones have been softly smudged and blended.

SMUDGING FOR EFFECT
The surface of pastel paper tends to fill up very quickly, and it can be tricky to build up layers of color and a sense of depth because the later layers of pastel will smear and smudge. However, for soft skin tones, these effects can enhance your work.

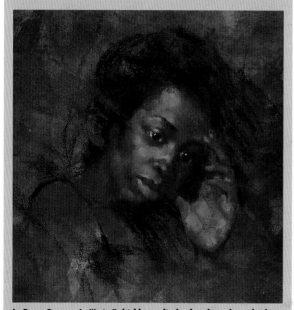

In Doug Dawson's "Lois," thickly applied colors have been laid over and pushed into one another.

FLOWERS

Flowers are well-suited to the brilliance of pastel. Unless you intend to simplify and treat a floral subject as broad masses of color, however, it is easy to go wrong with the complex structures. Keep your pastel marks light initially and build up the colors gradually.

CONVEYING FRAGILITY

To create a sense of fragility when painting delicate flowers, try working directly on white paper. This will soften all your colors and make the flowers appear less solid.

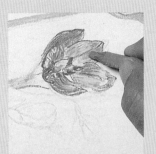

Light marks are made with a pastel pencil.

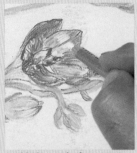

Highlights are built up, again with a pastel pencil.

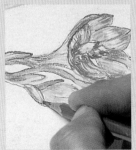

(Above) The drawing is sharpened up with a 6B pencil.

(Right) The smooth, watercolor-paper surface helps to keep the lines light and delicate.

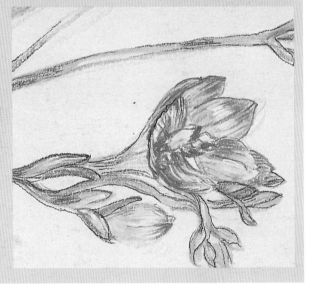

UNDERSTANDING THE STRUCTURE Flowers are extremely hard to paint because their structures are so complex. When you begin, try drawing the flowers on tinted paper with pastel pencil. Follow the line of the plant up the stem in the direction of growth to the tips, following the natural line of the plant. Then fill in the petals with softer pastels to create intensity of color and lightness of form.

White pastel pencil is taken around the main shapes.

Soft-pastel strokes follow the forms of the petals.

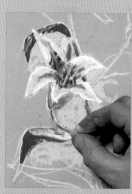

(Above) The pale background color is applied.

(Right) The fine sandpaper used holds the pigment well and encourages firm, positive drawing.

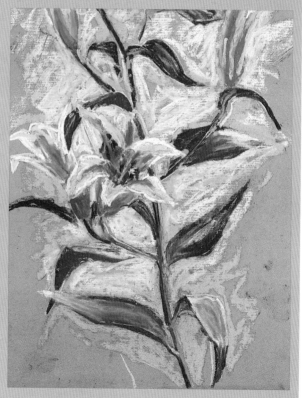

ACKNOWLEDGMENTS

The author would like to acknowledge the invaluable help given
by the following artists and experts while researching this book:
Rosalind Cuthbert, Miranda Creswell, Brian Dunce, Charles Glover,
Emma Pearce (Technical Advisor, Winsor & Newton), Jackie Simmonds
and Frances Treanor.

Quarto would like to thank George Cayford, Patrick Cullen, Debra Manifold
and Jane Strother for demonstrating the techniques.

Quarto would also like to thank Daler-Rowney and Langford & Hill for
supplying paints and equipment.

Art editor Clare Baggaley
Designer Clive Hayball
Photographers Paul Forrester, Chas Wilder, Laura Wickenden
Picture researcher Laura Bangert
Editors Hazel Harrison, Cathy Meeus, Jane Royston
Editorial director Sophie Collins
Art director Moira Clinch

Typeset by Poole Typesetting (Wessex) Ltd, Bournemouth
Manufactured by Bright Arts (Singapore) Pte. Ltd
Printed in Singapore by Star Standard Industries Pte. Ltd